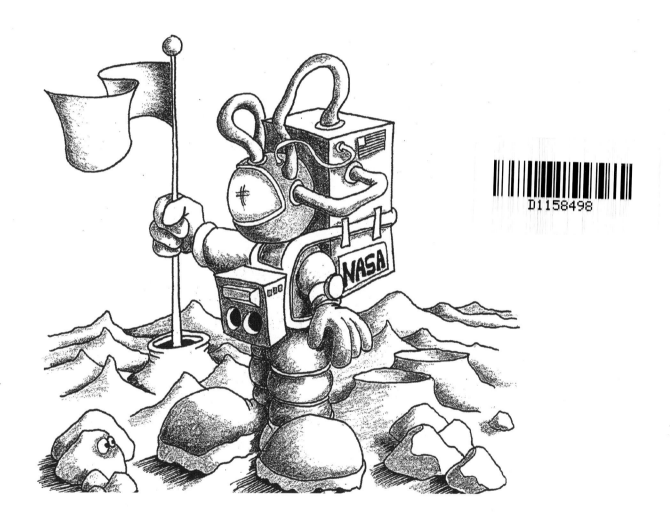

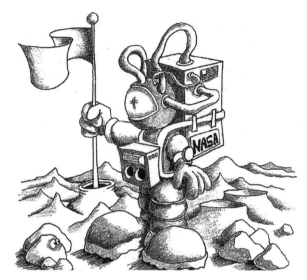

DRAW! DRAW! DRAW!
CRAZY CARTOONS

DRAW! DRAW! DRAW!
CRAZY CARTOONS
with Mark Kistler

Author Planet Press

Draw! Draw! Draw! series by Mark Kistler includes:
Monsters & Creatures
Cartoon Animals
Crazy Cartoons
Robots, Gadgets & Spaceships

Source: This work is an expanded edition of the book initially titled *Learn to Draw in 3D: Crazy Characters*, published by Scholastic Inc. in 2002

Publication facilitated by Author Planet Press, 2014

Author Planet Press
7741 South Ash Court
Centennial, CO 80122
www.authorplanet.org

Additional material by Mark Kistler
www.MarkKistler.com

Designed by Carissa Swenson
Additional Design for Expanded Edition by Chuck Crouse
Cover illustration by Mark Kistler
Illustration inking by Chrysoula Artemis of Starlight Runner Entertainment

ISBN: 978-1-939990-08-2

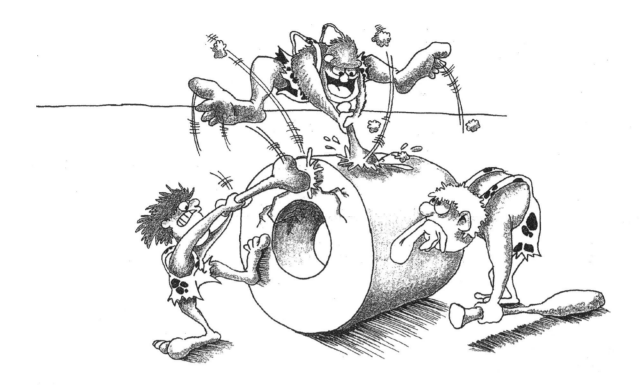

This book is dedicated to my good friend and Executive Producer Robert Neustadt.
Thanks for twenty years of sharing the dream.

WHAT'S INSIDE

You Can Draw!

Greetings, Genius Cartoonist!

Have you ever heard someone say, "I can't draw, I don't have any talent?" Well, I'm here to teach you that anyone who can make a scribble on a blank piece of paper can learn how to draw great cartoons in 3-D.

All of my crazy cartoon characters start with one simple line—from the most compicated drawing of a Nice Neanderthal to the simplest sketch of a cartoon face. From that simple beginning line, you will learn how to add layers of neat detail, to build, shape, and refine one simple step at a time, until "VOILÀ!"—an amazing 3-D cartoon image emerges from your blank piece of paper! I'm anxious to introduce you to a whole family of fun cartoon characters I call my Pencil Pals.

Let's get started!

MARK KISTLER

ix

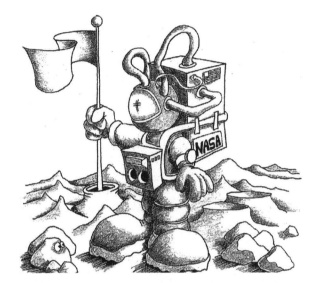

DRAW! DRAW! DRAW!
CRAZY CARTOONS

WHAT YOU NEED TO GET STARTED

1. Pencil
2. Paper

That's it! A sharp pencil and a blank sheet of paper are the only items you need to launch your brilliant imagination into the galaxy of cool cartooning in 3-D adventures!

BONUS SUPPLIES

To help you practice your important drawing skills every day, here is a list of bonus supplies you might want to collect over the weeks and months ahead:

1. Mechanical pencil 9mm hb lead (medium tip — good for blocking in sketchy lines)
2. Mechanical pencil 9mm b lead (soft tip)
3. Mechanical pencil 9mm 2b lead (softer tip — good for shading)
4. Pack of 6 to 12 paper stumps (for blending your shading)
5. Several spiral bound blank sketchbooks in different sizes
6. A pack of colored pencils
7. A few fine and ultrafine black ink pens/markers
8. A special book bag to hold your supplies — your own "cartooning kit"

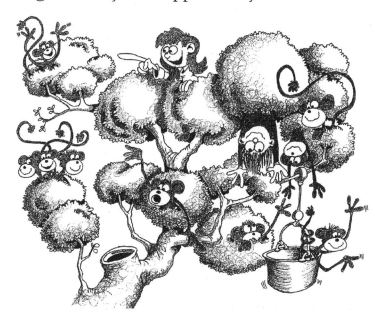

Before we start drawing our crazy cartoon characters, let's warm up by practicing **shading**. When you add shading to round objects like legs, feet, and toes, blend the shading to create a smooth tone from dark to light. You'll want the edges farthest away from the light to be really dark. Then blend the shading lighter and lighter as it curves around toward the light. Always blend the shading on curved or rounded objects. Shade a solid tone across flat or square objects.

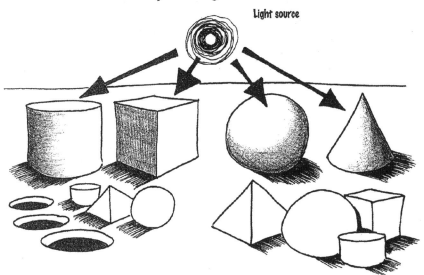

Now practice drawing cast shadows. Cast shadows help anchor your crazy characters to the ground, so they don't look like they're floating away. *Oh, no . . . help me . . . I'm floating away!* Notice that the shadows are on the side of the object that faces away from the imaginary light source. Don't let the shadows droop down vertically, or your character will look like it's standing on melting ice.

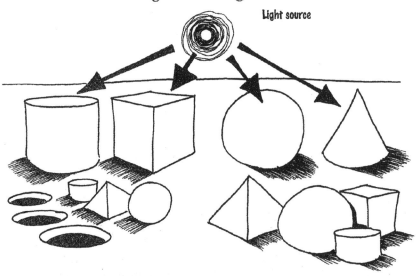

2

DRAW! DRAW! DRAW!

DRAW! DRAW! DRAW!

FACES

Let's start with my favorite part of every crazy cartoon character—the face. We will start with simple, basic shapes and easy-to-follow steps. Before you know it, you are going to be drawing super-detailed 3-D cartoon illustration just like the pros!

CARTOONING LESSON #1

1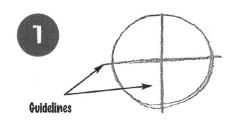

Guidelines

Begin with a simple circle. Draw two lines that criss cross through the middle of the circle. These **guidelines** create a grid that will help you place the eyes, nose, mouth, and ears.

2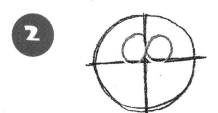

Sketch two eyes in the top sections of the grid. You can make them different sizes for a wackier, wilder expression.

3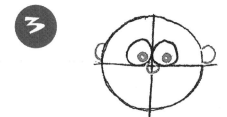

Darken the pupils, leaving a little white spot. Use the grid to **position** the nose and ears. Experiment by placing bigger ears or a giant nose lower on the grid.

4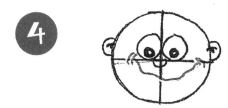

Add **detail** to the inner ear. Then go scribbly nuts with the grin, turning it up on either side of the vertical grid line. Add curving **contour** lines at the edges of the grin to form smile lines.

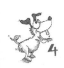

5

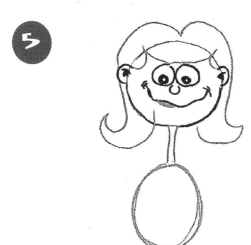

Let's draw some poofy hair and darken the mouth just a bit to make our crazy character look like she is giggling. I'm going to draw an exaggerated long neck. You can draw a short one, a skinny one, or even a neck that stretches the entire length of your paper! Then lightly **block** in the shape for her body.

6

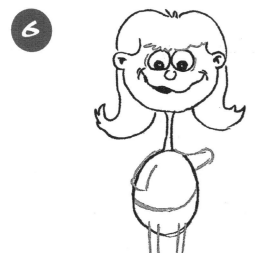

Guidelines

Block in where the arms and legs will go. Then draw two slightly slanting guidelines for the feet.

ART ALERT!
Try an experiment. Draw this face one more time without the smile lines. Notice how a few simple lines can make a huge difference in your cartoon's facial expression.

7

Draw the guidelines for the tip of each sho Add details like fingers, socks, and dark ha Curve the belt lines around the surface of tl body, using contour lines. Contour lines gi the body its shape.

ART ALERT!
Flip to lesson 3 for more details on drawing 3-D cartoon feet.

Light source

8

Yippee! My favorite part of every lesson — final details and cleanup! To complete this drawing, determine where the imaginary light source will be placed in the picture and shade the side of the character opposite this light source. Then add a **cast shadow** on the ground next to each foot. Notice how the shadow pops that foot right off the surface of the paper!

Cast shadow

For fun, draw the cartoon girl's little brother next to her. Follow the exact same lesson steps you just completed, but shorten the hair and change the details.

For even more fun, try drawing these variations on the cartoon face:

Frightful Frank, Three-quarter View

Curious Carl, Side View

Super-screamer, Front View

HANDS

Look at the pencil you are holding in your hand. Notice how your fingers grip the pencil. Hands are amazing for clamping, grabbing, waving, pointing, and making gestures! When you learn how to draw hands in different positions, your cartoon characters will become active, expressive, and unique.

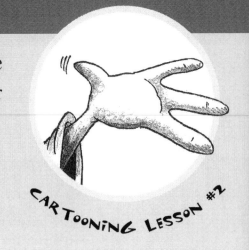

CARTOONING LESSON #2

1

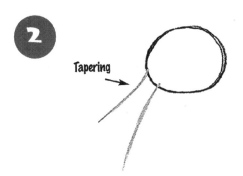

Begin the waving hand with a light, sketchy circle.

2

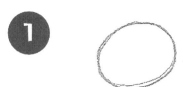

Tapering

Draw two lines to form an arm. Make the arm narrow toward the wrist—this is called **tapering**.

3

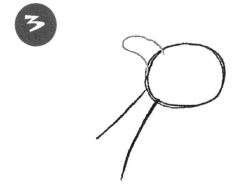

Loop the thumb back from the top of the circle. I think of drawing bananas when I draw thumbs and fingers.

ART ALERT!
Remember, words in bold are explained at the back of the book.

4

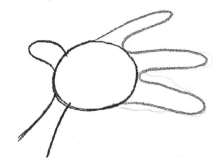

Flair the fingers out from the other side of the circle. You can keep them close together or flair them apart like I have done, to give your waving hand more action. I like to draw just three fingers and a thumb.

5

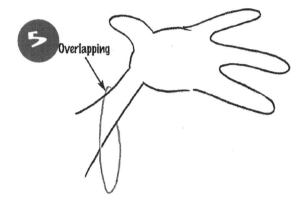

Overlapping

Add a **foreshortened** circle around the wrist to block in where the wrinkled sleeve will **overlap** the arm.

6

Light source

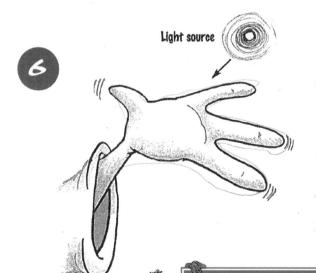

Time for the fun part! Darken in the outlines, add **shading** to all the areas opposite the imaginary light source, and **clean up** any extra lines. Draw a few action lines at the tips of the fingers to create the illusion of movement.

ART ALERT!

Foreshortened circles look like you grabbed both sides of a circle and stretched it like a rubber band. They really make your drawings look 3-D.

9

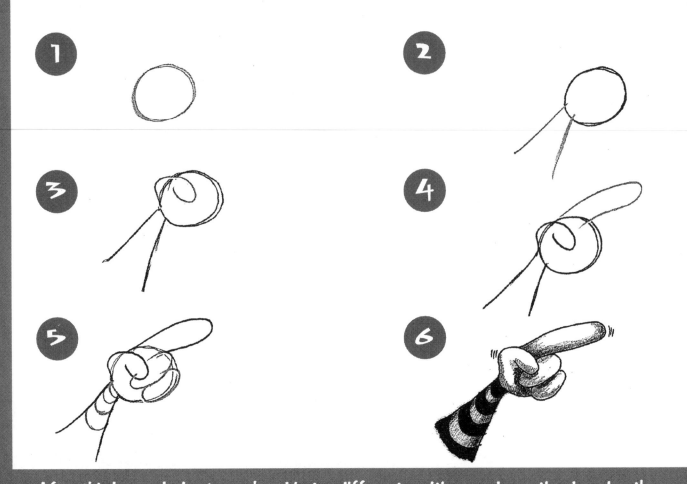

After this lesson, look at your hand in ten different positions and practice drawing them in your sketchbook. Remember, we are creating fun, wacky cartoony hands. Don't worry about drawing every wrinkle, knuckle, and fingernail exactly like your real hand! Spend only thirty seconds on each drawing to get the feel of different positions. Now switch your pencil to your other hand and try more quick, thirty-second gesture drawings. I know this feels weird, but it will get you to scribble the fingers freely without getting all caught up trying to be super-technically correct. Here are some of my ideas—a hand carrying a bucket, holding a magic wand, and two hands gripping a tree branch.

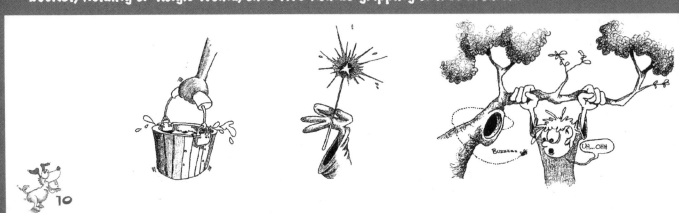

FEET

Stomp! The giant's enormous foot came crashing down on top of the bush I was hiding behind. I stood there frozen, as stiff as a Popsicle, staring at the gigantic hairy towe. It was like a wall in front of me, totally blocking out the sun. Before I could blink three times I felt the giant lifting me up by my backpack... Let's draw the giant's hairy foot in 3-D!

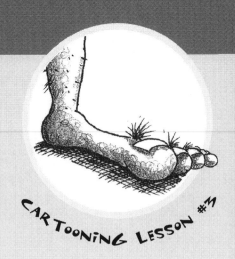

CARTooNiNG LeSSoN #1

1

Start with a simple circle.

Tapering

2

Draw two **tapered** lines for the giant's leg. The space between the lines should get narrower at the ankle. Let's draw one complete leg first. You can draw the second leg later on.

3

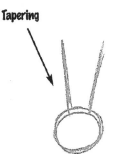

Draw a **guideline** at the base of the circle, slanting down a bit. This helps you to plant the foot solidly on the ground. By using a slanted guideline, the big (lower) toe will look much closer to you than the rest of the toes.

Guideline

ART ALERT!

This exercise illustrates the vocabulary words, "position" (parts of the cartoon that are closer are placed lower) and "size" (parts of the cartoon that are closer are drawn larger).

4

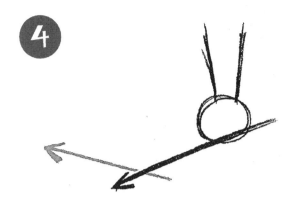

Angle up the front of the foot with another guideline. This will be the guideline you'll follow when drawing the toes.

5

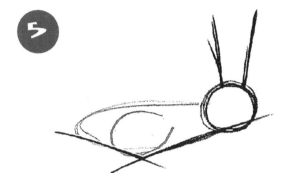

Block in the enormous big toe.

6

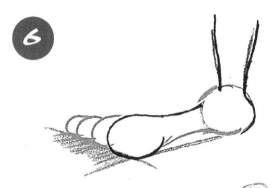

Now draw the other toes, getting smaller as you tuck them behind the big toe. Define the bottom arch of the foot and the back of the heel.

Light source

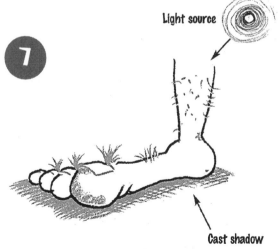

Cast shadow

7

Place a dark **cast shadow** on the ground opposite the **light source**. Have some fun with tiny **details** like scraggly hair, an ankle bone, and toenails. Be sure to curve each toenail over the top of the toe. Line up the side edge of the toenail with the guidelines at the bottom of the foot. Those guidelines sure are handy, eh?

13

8

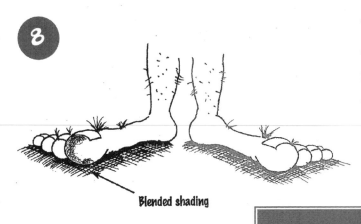

Blended shading

Time to go NUTS with details and cleanup! Then draw the other foot by following the exact same steps as you did for the first one — just reverse the direction of the toes.

ART ALERT!

Hey, here's a wild idea! How about drawing a cartoon character with four left feet and four right feet? Pencil Power with legs!

9

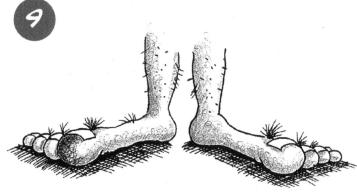

Final step! Shade more! Cleanup!

Use the important ideas you learned in this lesson to experiment with different kinds of cartoon feet. I've drawn a monster foot and a robot foot. I want you to draw fun, freaky feet for a turtle, a Martian, an octopus, a centipede, and anything else you can imagine.

CARTOONING LESSON #4

You sit hunched over your sketchbook, diligently drawing. "Just wait until the King and Queen see this masterpiece!" you say to yourself.

Suddenly, you feel inspired. You invent a brand-new crazy 3-D character. Then you jump up, hold your pencil high over your head, and yell at the top of your lungs, "I am a great cartooning genius—the Prince of Pencil Power!"

1

Draw a simple, light circle to **block** in the head.

2

Sketch in a smaller circle on the top left edge to **position** the prince's left eye.

3

Make his right "peekaboo" eye smaller and tuck it behind the closer, larger eye. Add the cartoon nose. You can make a big nose, a small nose, a drooping nose, a Pinocchio nose . . . you get the point.

ART ALERT!
Remember, words in bold are explained at the back of the book.

Draw a curved line for the top of the mouth. Add a few smile lines to give your cartoon character a fun expression.

Overlapping

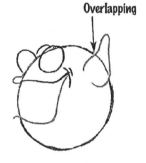

Open the mouth up with a curving line. The elf-shaped ear **overlaps** the top right edge of the head.

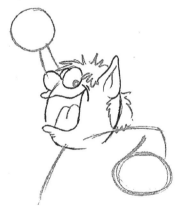

Block in the arms, hands, and body. Then start working on the **details.** Notice how the hand that is closer to you is blocked in with a larger circle, and the closer arm widens to give the illusion that it's "popping out" in **3-D?**

Tapering

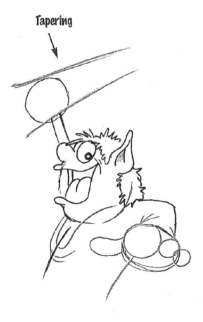

Block in the giant pencil with two **tapered** lines and start adding details to the hand that's reaching toward you, the looping shirt collar, and the inside of the mouth. Notice how big the pointing index finger is? This is a great example of **foreshortening** and **size** working together.

17

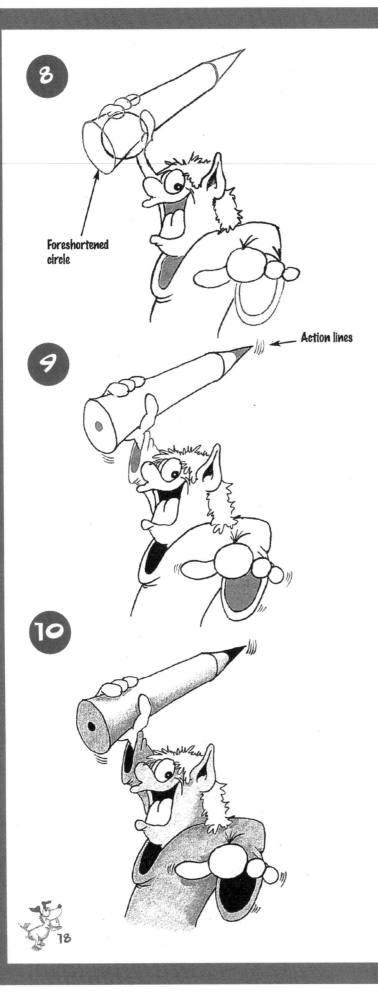

8

Draw a foreshortened circle at the bottom end of the pencil, making it appear larger and closer to you than the sharp pencil tip. Draw the fingers and thumb overlapping the edges of the pencil. Make sure the fingers get smaller as they get farther away. Loop down the sleeve of the closer arm with a curved line.

Foreshortened circle

9

Action lines

Darken the collar and shirt sleeves. Add details like **action lines** and the tip of the pencil.

10

Final step! YAHOOOO! Details! Darken! Shade! Shadow! Clean up! Erase!

GUITAR GHOST

You want music while you draw? Who are you going to call? Guitar Ghost! Let's draw some rockin' and rollin', floating Guitar Ghosts!

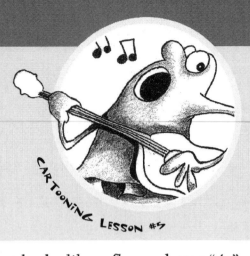

CARTOONING LESSON #5

1

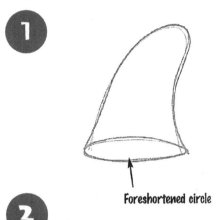

Foreshortened circle

Draw a shape that looks like a floppy letter "A." **Block** in the bottom of the hovering ghost with a **foreshortened** circle.

ART ALERT!

At this point, you could use this shape to draw a jellyfish, a mushroom, or even a Tree Troll like this one.

2

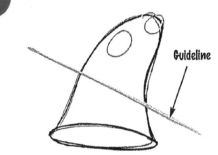

Guideline

Overlap the eyes. Then draw a foreshortened circle for the ghost's gaping mouth and a quick **guideline** to help you place the guitar.

3

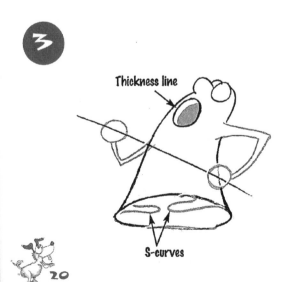

Thickness line

S-curves

Draw the nose and add a **thickness** line to the inside of the mouth to show thickness. Use the guitar guideline to help you position the hands. Now comes the interesting challenge — making the ghost look like it's billowing in the wind. Watch this! Draw two "S" curves inside the bottom foreshortened circle. See how it already looks like a flapping sheet?

4

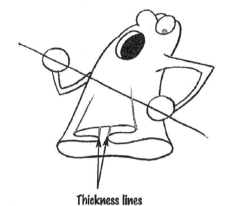

Thickness lines

At the base of the ghost, draw two thickness lines up from each edge of the "S" curves. It is very important to "peekaboo" tuck these lines behind the front edge of the billowing sheet.

5

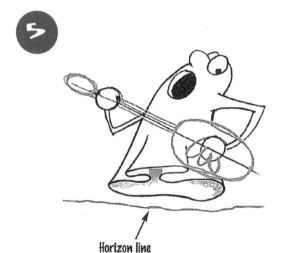

Horizon line

When you add the dark **shadows** inside and behind the overlapping folds of the ghost, the outside edges will POP out in 3-D. **Contrast** is an important tool in your 3-D cartoons. Draw the **horizon line** below the ghost to give the illusion that it is hovering above the ground. Block in the guitar around your guideline.

6

Light source

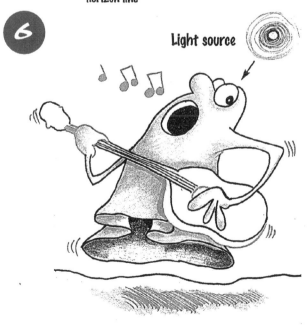

FINAL STEP! WAY TO GO! This looked like a very easy drawing but turned out to be one of the more difficult ones. Add **shading**, a few wiggling **action lines**, and some music notes. Then clean up any extra lines. By adding a **cast shadow** on the ground, you strengthen this visual illusion of floating. There you are — your very own 3-D, hovering, music-blaring, Guitar Ghost rock star!

Moon Mission

Now that you can draw basic 3-D characters, are you ready to tackle a more advanced 3-D cartoon? The lesson below is based on the world-famous photograph of you officially opening Moon Base Alpha for human colonization. It is a good picture of you. I'm sure your parent are very proud of your accomplishment.

CARTOON LESSON #6

1

We're going to start this character by learning to draw a **3-D** cube. First, place two dots far apart and straight across from each other.

2

Put your finger between these two dots and draw a dot above and below your finger, like I have done here.

3

Connect these four dots to create a **foreshortened** square. This squished square will be at the top of the box.

Draw a long vertical line straight down from each of the three front corners of the foreshortened square. Draw the middle line longer than the other two. This will help us create the illusion that one corner of the box is closer than the others.

Connect the bottom of the box with two slanting lines. They should be parallel to the lines you drew above. Lightly **block** in a circle on the left side of the box. This will become the Moon Walker's space helmet.

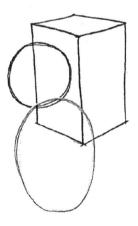

Block in the body with a slightly larger oval. Keep it loose and sketchy.

7

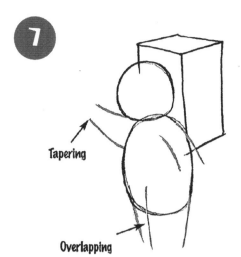

Tapering

Overlapping

Lightly block in the position of the arms and legs. Use **overlapping** and **tapering** to achieve a 3-D effect.

8

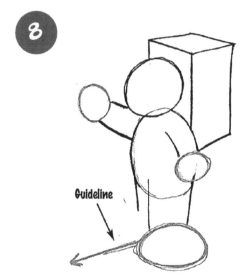

Guideline

Block in the hands and left foot with quick sketchy circles. To create the illusion that this foot is pointing directly at us, draw the very tip of the shoe really large. Then draw a **guideline** to position the other foot.

9

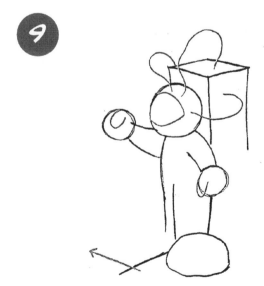

Now begin adding the fun **details**. Block in the three air hoses attaching the helmet to the oxygen pack. Then draw the helmet's rounded visor. Begin the gloved hands by drawing an oversized thumb overlapping each circle. Add another slanted **guideline** to help you position the right foot.

10

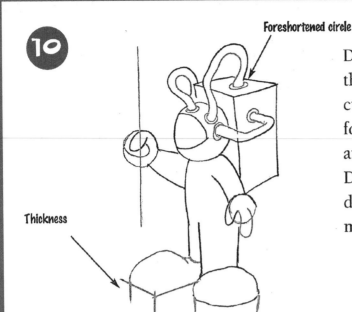

Foreshortened circle

Thickness

Draw a quick **line** to position the flag in the Moon Walker's hand. Then draw curling fingers overlapping the line to form a gripping fist. Finish the air hoses and add foreshortened circles at each end. Draw the **thickness** of the boots. Little details like these make your cartoon much more interesting to look at!

11

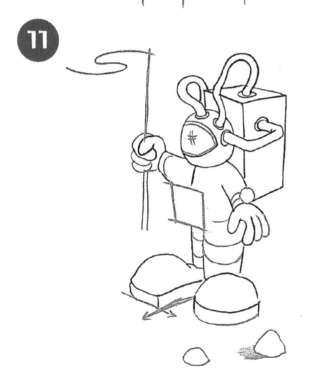

Let's draw the top of the flapping flag with a foreshortened "S" curve. Curve **contour** lines around the legs to give the space suit its shape. Then, using the lines you have drawn for the moon boots as a **reference**, **sketch** in the high-tech belly pack.

ART ALERT!

Match the angles and lines in your drawing to get a more realistic 3-D look. This is called "alignment." Compare the two boxes below. I used alignment to draw the box on the left, but not the box on the right. Do you see a difference?

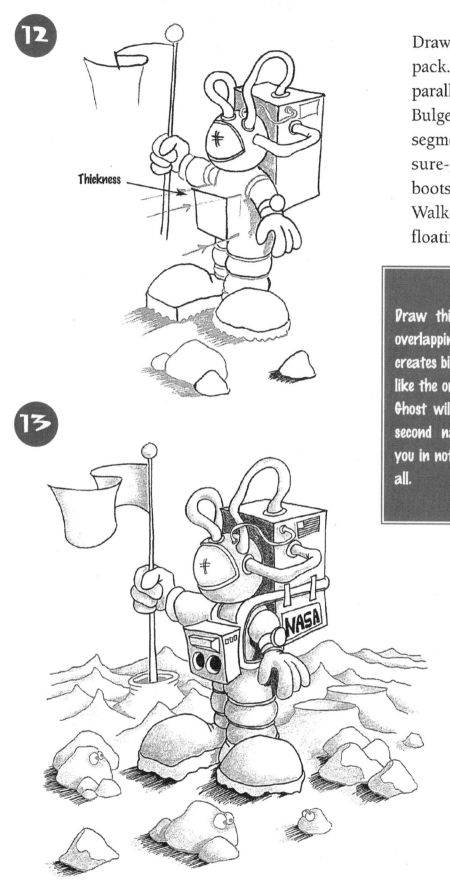

12

Thickness

Draw the thickness of the belly pack. These new lines should be parallel to the lines of the boots. Bulge out the padded suit leg segments and draw the jagged sure-grip soles of the moon boots. (We don't want the Moon Walker tripping over rocks and floating off into space!)

ART ALERT!

Draw this simple flag to practice the overlapping "peekaboo" effect that creates billowing fabric. Overlapping folds like the ones at the bottom of the Guitar Ghost will become second nature to you in not time at all.

13

Add as many bonus details as you want. The more the better! Pay close attention to the dark **shadows** cast onto the moon's surface by the boots and rocks, and take a good look at how I finished up the bottom of the flag.

NICE NEANDERTHALS

Here's a cartoon portrait of my brothers and me. We often get together to "bang around" a bit. In this picture, Steve and Karl are inventing the wheel with delicate precision and a well-thought-out design plan. I'm the dude on the right looking very confused about the whole process. Draw a cartoon portrait of your family as happy Neanderthals.

CARTOONING LESSON #7

1 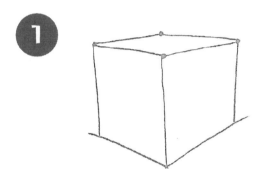 We are going to draw the wheel carved out of a chunk of stone. Start with a **foreshortened** box — just like you did for the Moon Walker's backpack.

2 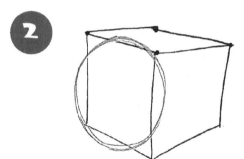 Believe it or not, the **3-D** wheel will fit inside this 3-D cube. Draw a circle on the left side of the box. It is perfectly okay to go outside the lines.

3 Follow the **guidelines** of the box to draw the top and bottom of the wheel.

4

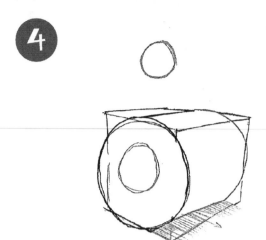

Punch out the center of the wheel. Then carve the back edge with a curving line. Begin **blocking** in the leaping Neanderthal's head with a loose circle above the wheel.

ART ALERT!

Clean up the extra lines of the box as you go, rather than waiting until the very end of a drawing. This way you won't get confused.

5

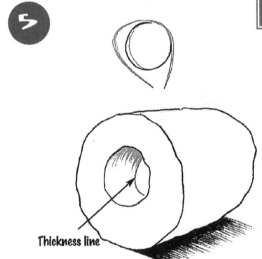

Thickness line

Draw the inside **thickness** of the hole in the wheel. Block in curved lines for the Neanderthal's arms.

6

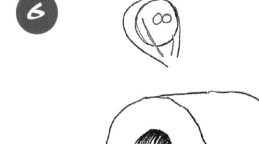

Overlap his right arm over his face. Remember to make it wider than the left arm since it's closer to you. Then add the eyes.

7

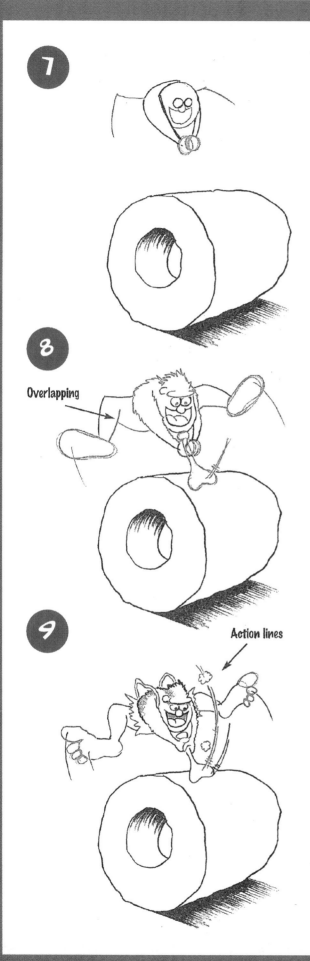

Block in the hands with light circles, and curve the leaping legs out from the body with two angled lines.

8

Overlapping

Sketch the thickness of each leg with tapered lines. Make sure the calves overlap the thighs on his legs. Block in the big feet with ovals and add some hairy texture on his arms and head. Draw the details of the face and block in the large bone in his hands.

9

Action lines

Wow! Good job! Now, let's focus on refining our furry Neanderthal buddy. Add his funky, ripped shorts and flapping suspenders. Draw some swooping action lines to create the illusion that he is really swinging that bone. Block in the round toes.

10

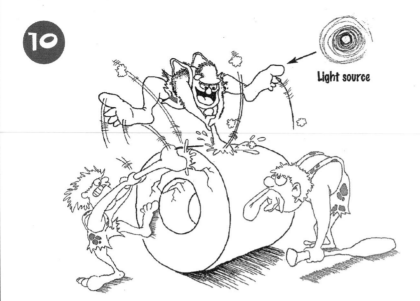

Light source

Decide where you want to place your imaginary **light source** and begin **shading**. Draw in the puffy clouds and "BANG" action lines where the bone smashes into the wheel.

11

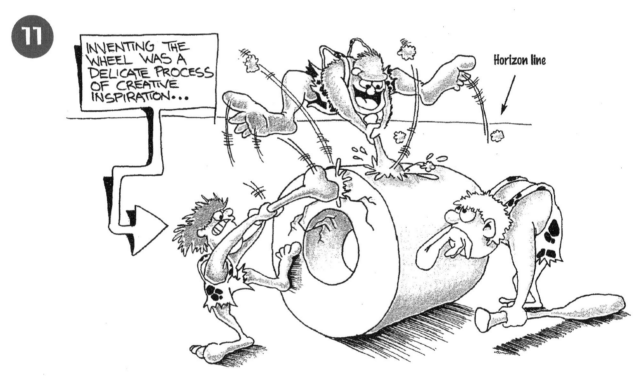

INVENTING THE WHEEL WAS A DELICATE PROCESS OF CREATIVE INSPIRATION...

Horizon line

Since we had so much fun drawing one Neanderthal dude, let's draw two more! Did you notice that the **cast shadows** next to the feet and the wheel anchor the entire picture to the ground? Add tiny details like stone-cracking lines. Draw in the long **horizon line** behind the Neanderthals and erase any extra blocking lines. Now go show this drawing to your friends! Great job!

32

PENCIL PALS

It's time for the test run of your time-traveling bathtub invention. You take a deep breath. You turn on the time tub's hot water faucet full blast. POOF! You find yourself in a very strange world of brilliantly colored pencil pals! There are Pencil People, Pencil Pooches, and even Pencil Ponies! Now this is an imagination adventure worthy of ten pages of drawing and story-writing!

CARTOON LESSON #8

Sketch a circle for the head. Remember to relax your hand and be super-messy. Have fun with these early shapes — you will **clean up** all the extra lines later in the lesson.

Draw a skinny neck and **block** in a larger circle for the body. Keep your lines loose and sketchy.

Now let's start blocking in the nose of the Pencil Pal by drawing two **tapered** lines.

ART ALERT!
Remember, words in bold are explained at the back of the book.

4

Draw a light, **foreshortened** circle at the wider end of the nose. Using **overlapping**, block in the eyes. Begin the legs by drawing two sets of tapered lines down from the body.

5

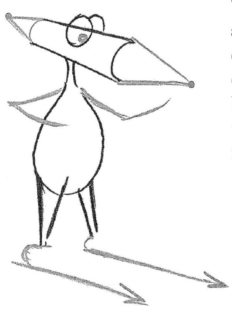

To draw the sharpened pencil nose, start with a dot about an inch away from the face. Then draw two lines from the face to the dot. Next, draw a shorter pencil point for the back of the head. Now, block in the flying wings and draw two long, slanting **guidelines** for the pencil feet.

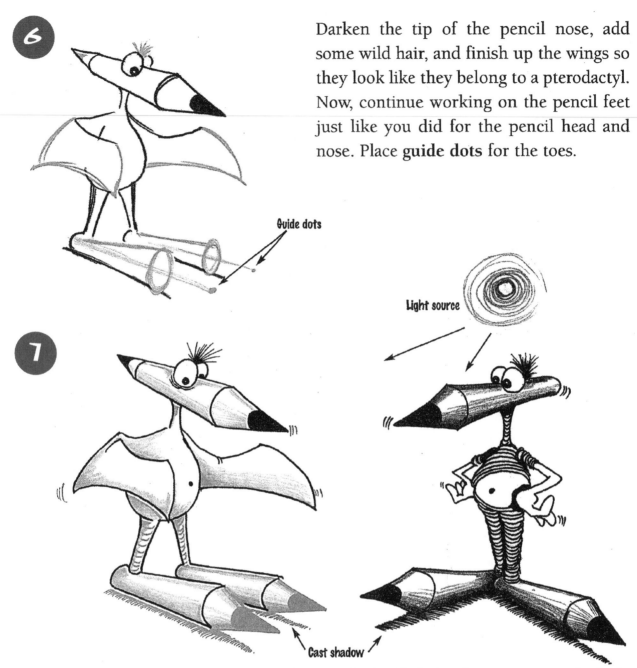

6 Darken the tip of the pencil nose, add some wild hair, and finish up the wings so they look like they belong to a pterodactyl. Now, continue working on the pencil feet just like you did for the pencil head and nose. Place **guide dots** for the toes.

Guide dots

Light source

7

Cast shadow

Complete the pencil feet with pointed toes. **Shade** all the surfaces opposite the **light source**. Notice how I followed the pencil foot guideline to draw a **cast shadow** directly under the toe? This cast shadow creates the illusion that the toe is lifting up off the ground. Erase any extra lines and clean up the final drawing. Then draw a friend for your Pencil Pal. Now make five hundred copies of this drawing and autograph them for all of your friends.

BiG MOUTH BOB

In this lesson I combined my intense love for reading great books with my love for drawing cool 3-D cartoons. Big Mouth Bob is a nice rock-muncher who helps kids read by giving them a comfortable place to relax with their books. Reading inspires your imagination to draw millions of extraordinary pictures!

CARTOONING LESSON #9

1 Draw **a large circle** using a light, sketchy line.

2 Begin drawing Big Mouth Bob's big mouth with a big, looping "A"-shape.

3 Draw the bottom half of the mouth with another loop. **Block** in a circle for Bob's left eye.

Draw his right eye smaller and tuck it behind the larger, front eye. Draw the lips.

5

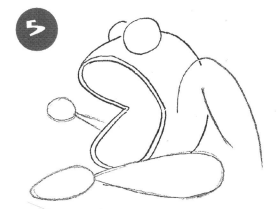

Lightly block in where the front leg and foot will be **positioned**. You will clean up all the extra lines later, so relax your pencil. Continue blocking in the closer shoulder and arm and the far hand.

6

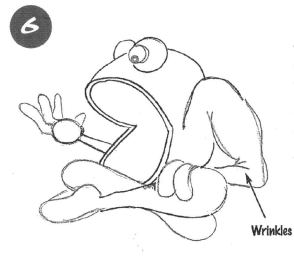

Wrinkles

Add the cool bulging eyeball. Draw the fingers **overlapping** the front leg, and the fingers bending up from Bob's right hand. Notice how the wrinkles on the front elbow make it look like the arm is bending toward the front leg? Wrinkles are great **3-D** details!

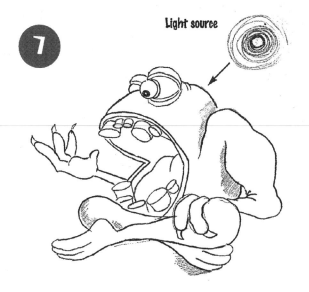

Light source

7

As you draw the large 3-D teeth, imagine you are drawing a row of soup cans. Also think about how each tooth will be positioned in order to make them look like they are jutting out of the mouth. The teeth that are closer to you should be larger and wider. They overlap the teeth that are farther away. (I thought of a hippopotamus mouth when I drew these teeth.) Then begin **shading**.

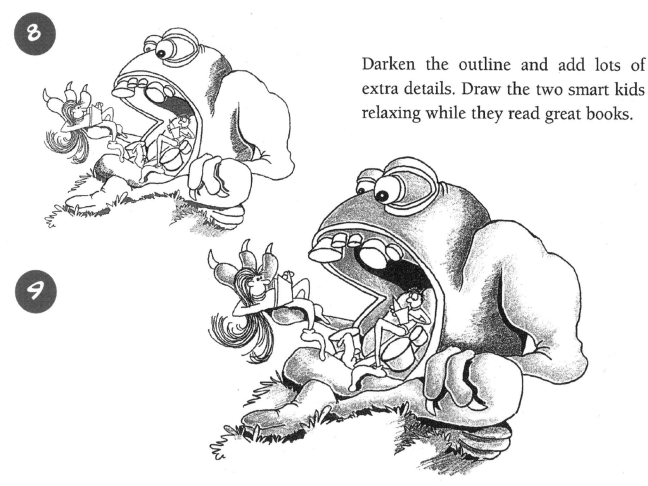

8

Darken the outline and add lots of extra details. Draw the two smart kids relaxing while they read great books.

9

Final step! Time to complete all the shading. Darken all the details, overlap the grass tufts, and add shadows. Congratulations on a drawing job well done! This is one of the most complicated 3-D cartooning lessons in this book!

TREETOP TAG

You have done an amazingly wonderful job on all nine 3-D cartooning lessons in this book! Now, let's create a unique world where all your new cartoon characters can live and play in 3-D! How about a world of trees so tall that there is a leafy canopy above the clouds? Then we'll draw your new cartoon character buddies playing a daringly fast game of treetop tag with the local population of monkey maniacs!

CARTOONING LESSON #10

1 Begin with a simple circle. This will **block** in the **position** of our first tuft of treetop leaves.

2 We are going to use a lot of **overlapping** in this cartoon environment. Tuck more circles behind the first one. Make the circles get smaller so they look like they are farther away.

3 Draw a thick tree trunk growing up through the first big circle you drew. Add a thinner branch growing off the trunk.

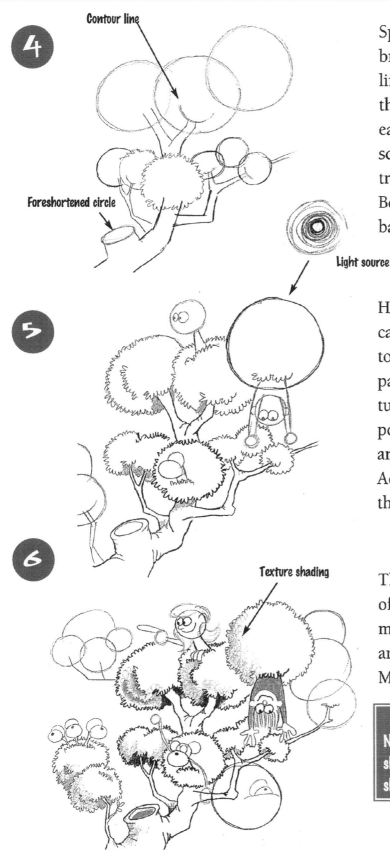

4

Contour line

Foreshortened circle

Split off the main tree trunk into two branches at the top. Curve **contour** lines above the branches to make them look like they stick directly into each **3-D** ball of leaves. Let's create a squirrel knothole on the main tree trunk with a **foreshortened** circle. Begin adding **texture** around each ball of leaves.

Light source

5

Have fun **blocking** in one of your new cartoon buddies popping out of the top tree tuft. Dangle another cartoon pal by his feet from the larger tree tuft. Determine where you want to position your imaginary **light source** and start the fun **shading** process. Add more scribbled leaves around all the blocked in circle-tufts.

6

Texture shading

This is where you really get to show off your brilliant imagination! Draw monkeys and cartoon buddies tearing and tumbling all across your treetops. Make a treetop tag free-for-all!

ART ALERT!
Notice how I'm using small, scribbled circles to shade all my leaf tufts? This is called "texture shading."

53

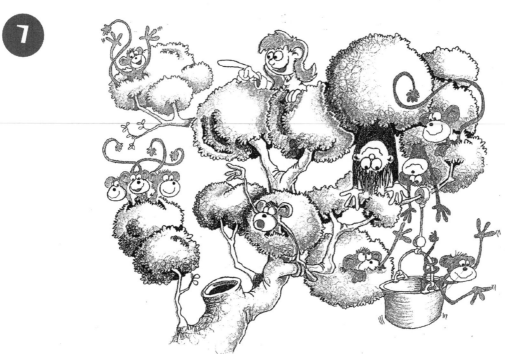

I'm having so much fun with these crazy monkey antics that I don't want to stop! Darken the outlines of the tree tufts and add the final **details**, **shadows**, and **shading.** You did a great job on this drawing lesson! You successfully created a brilliantly clever 3-D world for your cartoon characters to live in. Awesome!

CONGRATULATIONS, YOUNG CARTOONING GENIUS!

You have just completed 10 very advanced 3-D cartooning lessons! I'm VERY impressed with your daily drawing diligence.

Now I want you to hang up your 3-D cartoons all over your house, your bedroom, your refrigerator! Put your brilliant masterpieces all over your classroom, your artroom, your principal's office! Display your amazing genius renderings everywhere! The world has a right to see and enjoy your amazing art!

HERE ARE A FEW POINTS TO REMEMBER...

1. Practice drawing in your cartooning journal, or sketchbook, every day. The more you practice, the more 3-D your drawings will look.

2. Create a cartoon gallery of your brilliant artwork—on your refrigerator, your bedroom door, a wall, or anywhere you can. Mail copies of your 3-D cartoons to your grandparents, aunts, uncles, and friends. I want you to share your awesome talent with your family and the whole world!

3. Be sure to visit my Web site at **WWW.MARKKISTLER.COM** to draw more cartoons and tour the digital student art gallery.

DREAM iT!
DRAW iT!
DO iT!

Look for all the books in my
Draw! Draw! Draw! series:

Monsters & Creatuers
Cartoon Animals
Crazy Cartoons
Robots, Gadgets & Spaceships

You can learn from me personally in many different ways!

- **Other books:** Find my other drawing books, for kids and for adults, in your local bookstore, in online bookstores, or on my website: www.markkistler. com.
- **Real-time classes with me:** Learn with me at school, on line, or in a summer camp!
 - o **Live, weekly webcast lessons:** Interact and chat with me while you learn—I would love to see you! Sign up for my lessons at www.mark-kistler.com.
 - o **Summer art camps:** I offer summer art camps all summer long, all over the country! Learn more at www.markkistler.com.
 - o **School assemblies:** The best part of my cartooning career is having the opportunity to teach "Dare to Draw in 3-D" assemblies at more than 100 elementary schools each year. I offer both live and virtual assemblies! Visit www.markkistler.com for more information about my school visits and workshops.
- **Super awesome video lessons:** Learn at your own pace through my interactive, pre-recorded classes. I've created 400 super-cool lessons just for you. Find them at www.draw3d.com, or look for free samples on YouTube!

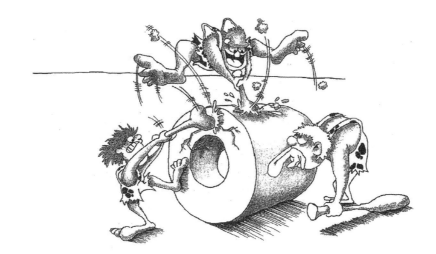

CARTOONING VOCABULARY WORDS

Learn these words and practice them each day in your cartooning journal. The more you practice, the more brilliantly 3-D your drawings will appear!

3-D
When you draw in "three-dimensions," you are creating a picture that has width, height, and depth. Every picture you have ever drawn has width and height. This is called a 2-D, or two-dimensional, picture. To successfully draw in 3-D you need to create the optical illusion of depth All the words below will help you create the look of depth in your picture.

Action Lines
Long action lines are quick strokes with your pencil and suggest the stretch, movement, and position of your cartoon critter. Short action lines are little curving lines around the edge of your cartoon object to suggest movement, wiggling, waving, or flapping.

Alignment
Use lines you have drawn earlier in a picture as reference lines to help you know where to position new lines.

Blend
Smudge shading with your finger or a paper stump to make it look like one smooth change from dark to light. On curved objects, always blend your shading from really dark to light as you move it across the surface of the object toward your imaginary light source.

Blocking
Almost every drawing you create will start with loose, sketchy lies that show the basic shapes that will be molded into a 3-D cartoon.

Cleanup
The very fun and rewarding final step in the cartooning-in-3-D process. After completing all the lesson steps in a picture, you get to erase all the extra lines, darken in all the outside edges, darken in the shadows and shading, and add lots of extra onus details to your cartoon.

Contour
Lines that curve around an object to give it shape and make it look like it takes up space.

Contrast	Drawing a dark area next to a light area to make the light area stand out.
Depth	If width is how wide a cartoon is, and height is how tall a cartoon is, then depth is how much space a drawing looks like it takes up from back to front.
Details	You really start to have fun when you begin adding lots of your own extra touches to your picture—like clothes, hair, a goofy smile, or even freckles.
Foreshort-ening	When you squish a shape to create the illusion that one edge is closer to you than the other.
Guide Dots	Always place guide dots when you are drawing foreshortened circles and fore-shortened squares. These guide dots will help you keep the shapes nice and foreshortened.
Horizon Line	Draw a line behind the objects in your picture to represent the ground. This line establishes a visual reference for your eye to relate to the ground, the sky, and the objects.
Light Source	The spot on your drawing where the light is coming from. The shadows and shading will be on the opposite side of the drawing—the side that faces away from light.
Optical Illusion	Our main goal with these cartoon drawing lessons is to trick your eye into thinking that the objects you have drawn on a flat piece of paper are pop-ping out in 3-D!
Overlap-ping	To make an object in your cartoon look closer than another object, draw it in front of the other object.
Position	Draw objects lower in the picture to make them appear closer to your eye. Draw objects higher and smaller to make them appear farther away and deeper in your picture.
Reference	Use the right and left edges of your paper to guide you when you draw lines straight up and down.
Shading	Darken the side of the object that faces away from your imaginary light source. Be sure to blend this shading on curved objects, and use a solid tone on block objects. Shading is a very important key to drawing in 3-D!

Shadow Draw dark areas next to objects opposite the imaginary light source to create a shadow on the ground. These cast shadows anchor the object in your picture to the ground so they don't appear to be floating up. Sometimes shadows drawn underneath a character can make it look like it's hovering above the ground—like the shadow you drew beneath Guitar Ghost.

Size Draw objects larger if you want them to look closer than objects that are drawn smaller in your picture.

Sketch The light rough lines drawn at the beginning of a drawing to get the basic shapes down on the paper. You can darken in the lines you want to keep in the final cleanup stage.

Tapering When part of a drawing—like Dino Dictator's chair—gets smaller and smaller at one end.

Texture Create a visual feel of surface on a drawn object—like the feel of bark on a tree, scales on a fish, fur on a bunny, etc.

Thickness Lines that help show how wide part of your cartoon critter is. Thickness can make belly packs, Big Mouth Bob's lips look blubbery, and nostrils look 3-D.

MARK KISTLER - BIOGRAPHY

Mark Kistler, with inimitable enthusiasm and style, has taught millions of children how to draw through his bestselling books, his popular PBS television series, his on and off-line classes and summer camps, and his more than seven thousand school assembly workshops around the world, including Australia, Germany, England, Scotland, Mexico, Japan, Spain and the United States.

He starred as Commander Mark and Captain Mark in the hit PBS television series The Secret City, The Draw Squad, The New Secret City Adventures, and his self-produced PBS series Mark Kistler's Imagination Station, which won an Emmy Award in 2010.

Mark's children's books include *Learn to Draw with Commander Mark, Mark Kistler's Draw Squad, The Imagination Station, Drawing in 3-D with Mark Kistler, and the four-book series Draw! Draw! Draw!* (originally titled *Dare to Draw in 3-D!*). His first book written for adults, *You Can Draw in 30 Days*, has become a category leader and perennial bestseller.

Online, Mark offers popular live and recorded classes. His YouTube videos alone have generated more than a million views. He has received more than a million letters and emails containing 3-D drawings from children around the world.

Mark deeply believes that learning how to draw builds a child's critical thinking skills while nourishing self-esteem. His positive messages on self-image, goal setting, dream questing, environmental awareness and the power of reading have inspired millions of children to discover their awesome individual potential.

Mark lives with his children in Houston, Texas, United States.

www.MarkKistler.com || www.MarkKistlerLive.com || www.draw3D.com
Facebook: https://www.facebook.com/artistMarkKistler
Twitter: @Mark_Kistler